THE

WICKED PLANTS

COLORING BOOK

AMY STEWART
AND
BRIONY MORROW-CRIBBS

Algonquin Books of Chapel Hill 2016

Published by
Algonquin Books of Chapel Hill
Post Office Box 2225
Chapel Hill, North Carolina 27515-2225

a division of
Workman Publishing
225 Varick Street
New York, New York 10014

Printed in the United States of America.
Published simultaneously in Canada by Thomas Allen & Son Limited.
Design by John Passineau.

10 9 8 7 6 5 4 3 2 1
First Edition

This Book

BELONGS TO

..

Consider Yourself Warned

A tree sheds poison daggers; a glistening red seed stops the heart; a shrub causes intolerable pain; a vine intoxicates. Within the plant kingdom lurk unfathomable evils.

Most of us approach our gardens and the plants we encounter in the wild with a kind of naive trust. We would never pick up a discarded coffee cup from the sidewalk and drink from it, but on a hike we'll nibble unfamiliar berries as if they had been placed there for our appetites alone. We'll brew a medicinal tea from unrecognizable bark and leaves that a friend passes along, assuming that anything natural must be safe. And when a baby comes home, we rush to add safety caps to electrical outlets but ignore the houseplant in the kitchen and the shrub by the front door—this in spite of the fact that 3,900 people are injured annually by electrical outlets, while 68,847 are poisoned by plants.

You can garden for years without ever suffering the ill effects of a plant like monkshood, whose cheerful blue flowers conceal a toxin that brings on death by asphyxiation. You can hike for miles and never encounter the coyotillo shrub, whose berries cause a slow but deadly paralysis. But someday, the plant kingdom's dark side may make itself known to you.

It's not my intention to scare people away from the outdoors. Quite the opposite is true. I think that we all benefit from spending more time in nature—but we should also understand its power. Plants can nourish and heal, but they can also destroy.

Some of the plants collected here have quite a scandalous history. A weed killed Abraham Lincoln's mother. A flowering bulb sickened members of the Lewis and Clark expedition. Poison hemlock killed Socrates, and the most wicked weed of all—tobacco—has claimed 90 million lives. A stimulating little bush in Colombia and Bolivia called *Erythroxylum coca* has fueled a global drug war, and hellebore was used by the ancient Greeks in one of the earliest instances of chemical warfare.

Plants that are monstrously ill-mannered deserve recognition, too: kudzu has devoured cars and buildings in the American South, and a seaweed known as killer algae escaped from Jacques Cousteau's Oceanographic Museum in Monaco and continues to smother ocean floors around the world. The whistling thorn acacia harbors an army of aggressive ants that attack anyone who comes near the tree.

I confess that I am enchanted by the plant kingdom's criminal element. I love a good villain, and there is something beguiling about sharing their dark little secrets. And these secrets don't just lurk in a remote jungle. They're in our own backyards.

—*Amy Stewart*

The drawings and text included in this coloring book are selected from *Wicked Plants: The Weed That Killed Lincoln's Mother and Other Botanical Atrocities*. To meet the rest of the plants, read more stories, and see artist Briony Morrow-Cribbs's beautiful copperplate etching illustrations, I hope you'll look for the book at your favorite bookstore.

Aconite

Aconitum napellus

In 1856, a dinner party in Scotland came to a horrible end when a servant, who had been sent outside to dig up horseradish, instead uprooted aconite. The cook grated it into a sauce and promptly killed two priests who were guests at dinner.

Even today, aconite is easily mistaken for an edible herb. The spikes of blue flowers give the plant its common name "monkshood," because the uppermost sepal is shaped like a helmet or hood. Gardeners should wear gloves anytime they go near it; even casual skin contact can cause numbness, tingling, and cardiac symptoms, and swallowing the plant or its roots can cause death by asphyxiation.

FAMILY:
Ranunculaceae

HABITAT:
Rich, moist garden soil,
temperate climates

NATIVE TO:
Europe

COMMON NAMES:
Wolfsbane, monkshood,
leopard's bane

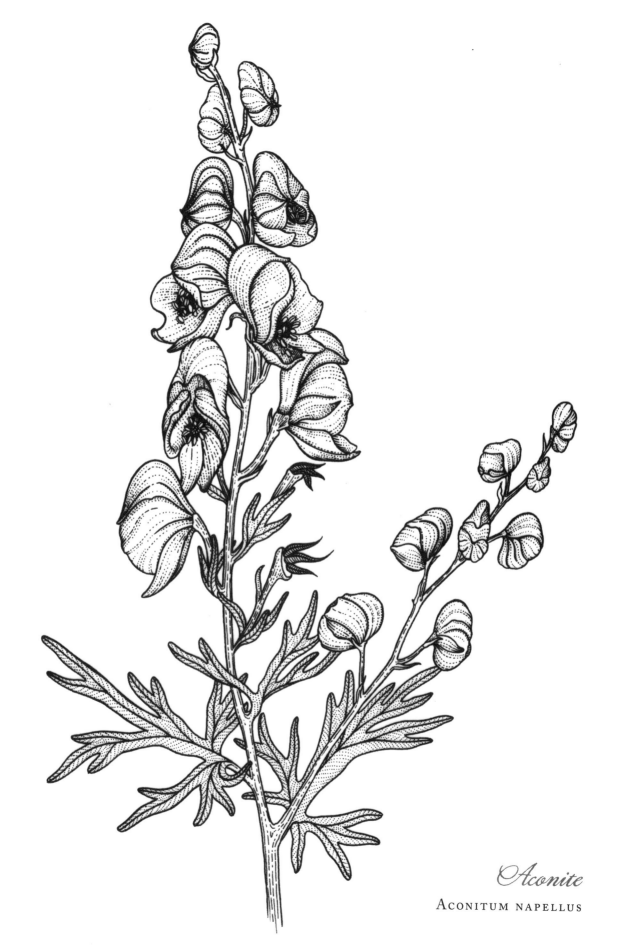

Aconite

ACONITUM NAPELLUS

Ayahuasca Vine

BANISTERIOPSIS CAAPI

FAMILY:
Malpighiaceae

HABITAT:
Tropical forests in
South America

NATIVE TO:
Peru, Ecuador, Brazil

COMMON NAMES:
Yage, caapi, natem, dapa

– AND –

Chacruna

PSYCHOTRIA VIRIDIS

The bark of the woody ayahuasca vine, brewed with the leaves of the chacruna shrub, form a potent tea called ayahuasca (or, hoasca). William S. Burroughs drank ayahuasca tea in the jungle and reported his findings to Allen Ginsberg.

The religious group União do Vegetal uses the tea in its ceremonies, which usually last for several hours. Participants experience bizarre hallucinations followed by extreme vomiting, which is seen as a purge of psychological problems or demons. People who have participated in the ceremony report that it relieved their depression, cured their addiction, or treated other medical problems.

FAMILY:
Rubiaceae

HABITAT:
Lower levels of the Amazon;
also found in other parts of
South America

NATIVE TO:
Brazil

COMMON NAME:
Chacrona

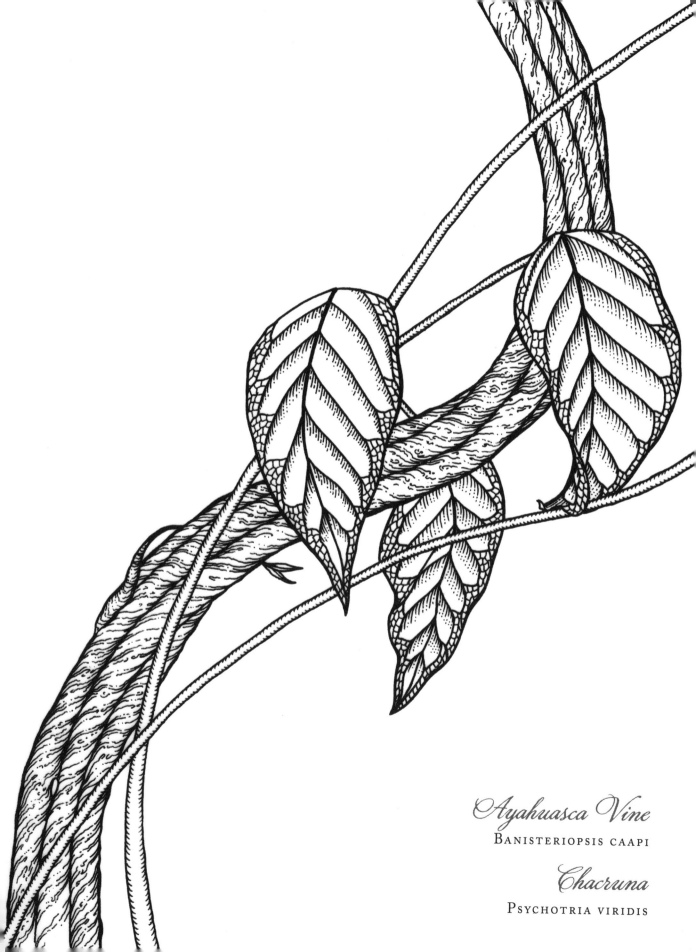

Ayahuasca Vine
BANISTERIOPSIS CAAPI

Chacruna
PSYCHOTRIA VIRIDIS

Betel Nut

ARECA CATECHU

The seeds of the betel nut palm, which contain addictive stimulants that turn teeth black and saliva red, are consumed by 400 million people worldwide. The custom of chewing betel nuts is quite ancient. Seeds from 5000 to 7000 BC were found in a cave in Thailand, and a skeleton from 2580 BC was discovered in the Philippines with teeth stained by the juice of the betel nut.

Public health officials worry that betel nuts could rival tobacco as a serious health threat, since, in addition to its addictive qualities, regular use leads to an increased risk of mouth cancer and may also contribute to asthma and heart disease.

FAMILY:
Arecaceae

HABITAT:
Tropical forests

NATIVE TO:
Malaysia

COMMON NAMES:
Betel palm, areca, pinang

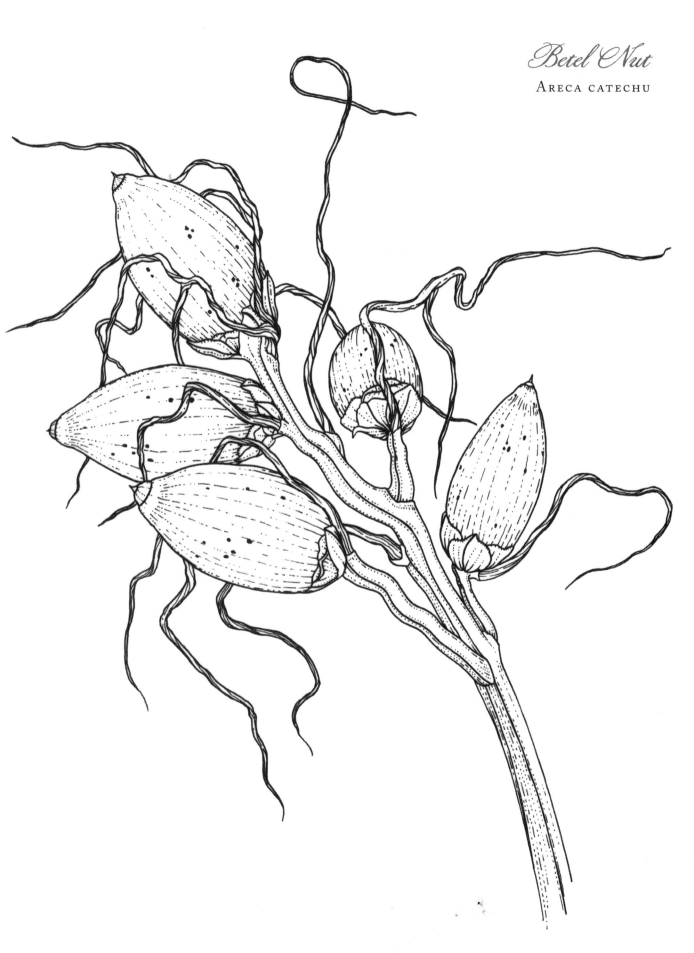

Betel Nut

Areca catechu

Bryonia

BRYONIA CRETICA

This sturdy, twining vine produces small, greenish-white flowers and red berries that cause vomiting, dizziness, and even respiratory failure. Its cousin, white bryony (*B. alba*) has been called "the kudzu of the Pacific Northwest" for its invasive behavior in that region. While the root of some species are used medicinally, all plants in the *Bryonia* genus are poisonous to humans and livestock.

FAMILY:
Cucurbitaceae

HABITAT:
Woodlands, hedgerows

NATIVE TO:
Egypt, Libya, Greece, Cyprus, Turkey, Syria

COMMON NAMES:
Snakeweed, bastard turnip, devil's turnip

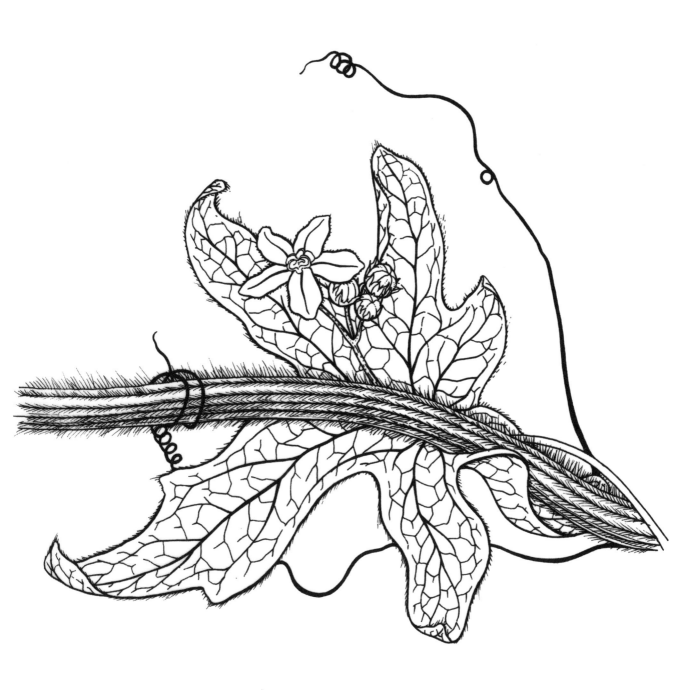

Bryonia

BRYONIA CRETICA

Castor Bean

RICINUS COMMUNIS

With deeply lobed leaves, prickly seed-pods, and large, speckled seeds, the castor bean is a dramatic addition to any garden. Some of the more popular varieties sport red stems and a splash of burgundy on the leaves. Only the seeds are poisonous, containing ricin, the very culprit of the "umbrella murder" of 1978, when a BBC journalist was jabbed in the thigh with an umbrella while crossing London's Waterloo Bridge and died days later (the human perpetrator was never found).

Castor oil has long been a popular home remedy—after the ricin is removed during manufacturing—and is used as a laxative and externally to relieve sore muscles.

FAMILY:
Euphorbiaceae

HABITAT:
Warm, mild winter climates, rich soil, sunny areas

NATIVE TO:
Eastern Africa, parts of western Asia

COMMON NAMES:
Palma Christi, ricin

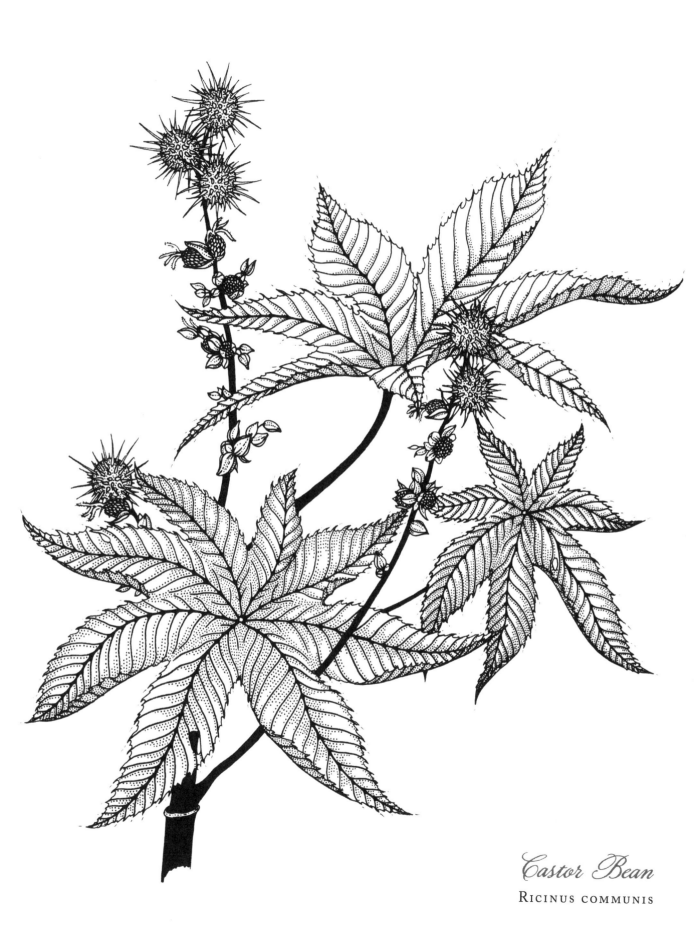

Castor Bean

RICINUS COMMUNIS

Coca

ERYTHROXYLUM COCA

When Spanish conquistadores arrived in Peru in the sixteenth century, they found that, with enough coca, the native Incan population they had enslaved could be forced to work quickly for long hours with very little food. In native Andean communities today, coca leaves are still chewed as a mild, nonaddicting stimulant. The leaves are surprisingly nutritious, prompting a minister in Bolivia to suggest that instead of milk, coca leaves should be fed to schoolchildren.

Cocaine, an alkaloid that can be extracted from coca leaves, has been used as an anesthetic, a pain reliever, and a digestive aid. Trace amounts were present in early versions of the soft drink Coca-Cola; coca extract is still believed to be a flavoring, just without the cocaine.

FAMILY:
Erythroxylaceae

HABITAT:
Tropical rain forest

NATIVE TO:
South American

COMMON NAME:
Cocaine

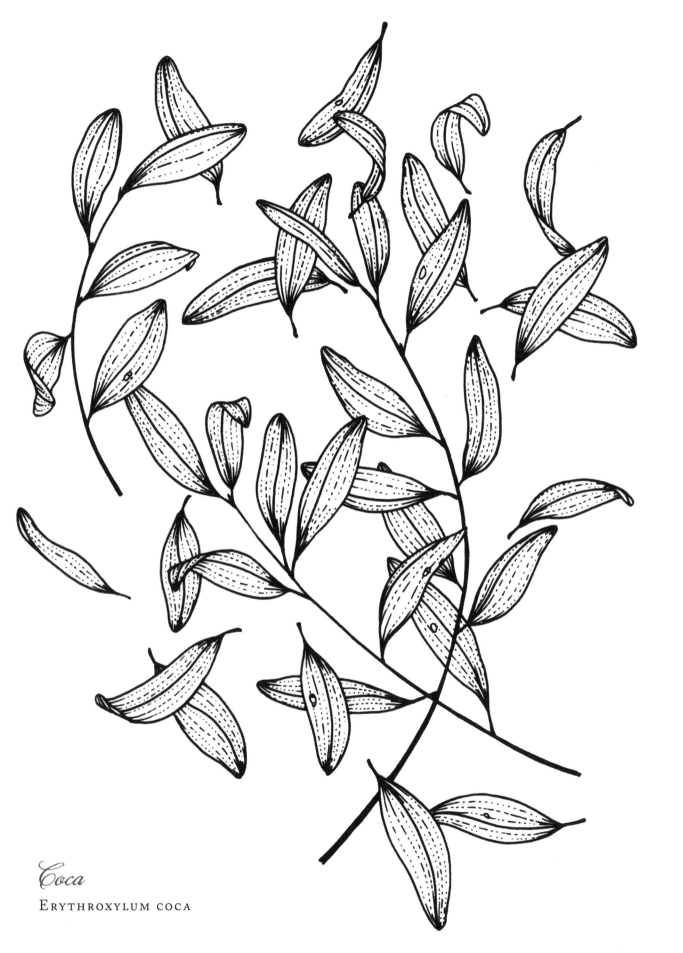

Coca

Erythroxylum coca

Coyotillo

KARWINSKIA HUMBOLDTIANA

The bright green, untoothed leaves and pale green flowers of the coyotillo make it an entirely forgettable shrub, but the round black berries it produces would be impossible to forget. Coyotillo berries contain a compound that causes paralysis several days, or even weeks, after ingestion.

The plant thrives in the canyons and dry riverbeds of southern Texas, New Mexico, and northern Mexico, posing a threat to animals and livestock who might graze freely on the shrub. Animals have been known to lose control over their hind legs, or to lurch backward for no reason, under the influence of this harmless-looking berry. For an animal, such a loss of mobility often leads to death.

FAMILY:
Rhamnaceae

HABITAT:
Dry southwestern desert

NATIVE TO:
American West

COMMON NAMES:
Tullidora, cimarron, palo negrito, capulincillo

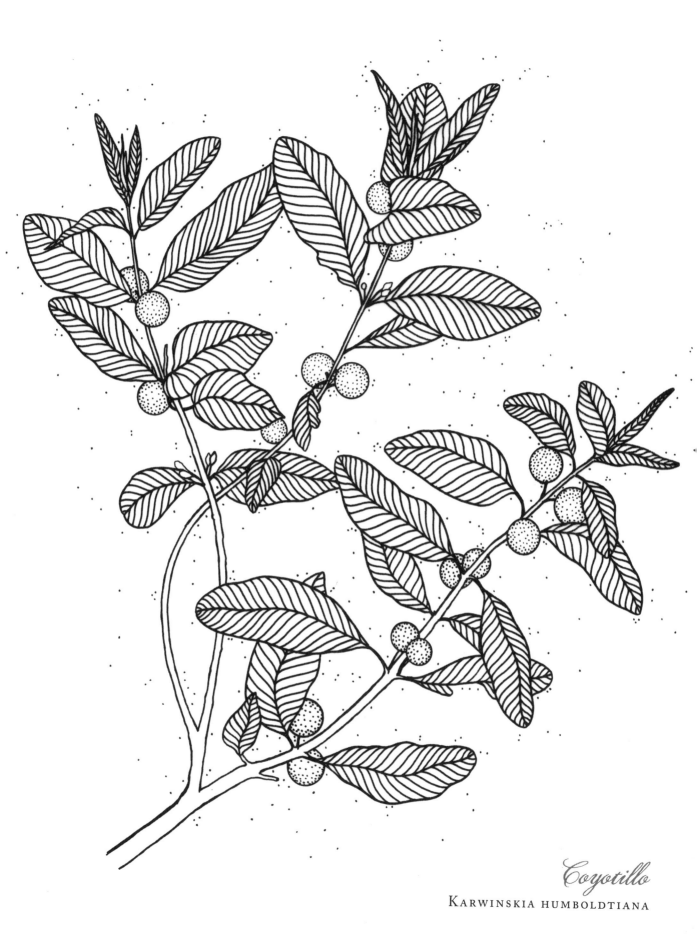

Coyotillo

KARWINSKIA HUMBOLDTIANA

Deadly Nightshade

ATROPA BELLADONNA

Although the entire plant is poisonous—just rubbing up against it can raise pustules on the skin—the black berries are the plant's most tempting feature. For centuries they have been mistaken for edible berries by unsuspecting foragers, causing hallucinations, confusion, rapid heartbeat, seizures, and possibly death.

Italian women dropped mild tinctures of deadly nightshade into their eyes to dilate their pupils, which they thought made them more alluring. The name "belladonna" may come from this practice; it means "beautiful woman," but the term might also originate from *buona donna*, a medieval witch doctor who treated the indigent with mysterious potions.

FAMILY:
Solanaceae

HABITAT:
Shady, damp areas; seeds need uniformly damp soil to germinate

NATIVE TO:
Europe, Asia, North Africa

COMMON NAMES:
Belladonna, devil's cherry, dwale (an Anglo-Saxon word meaning "a stupefying or soporific drink")

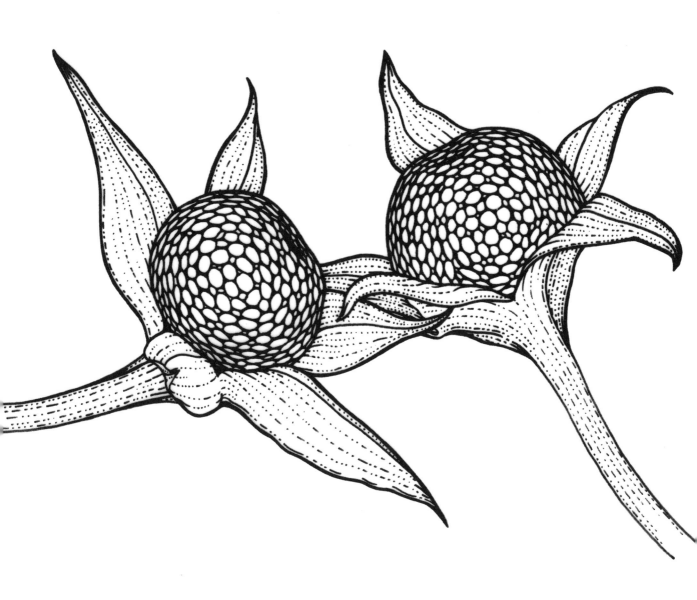

Deadly Nightshade

ATROPA BELLADONNA

Death Camas

ZIGADENUS VENENOSUS, OTHERS

Eating any part of the death camas plant—from the clusters of pink, white, or yellow flowers, down to the bulb—will cause drooling, vomiting, extreme weakness, and confusion. Severe cases may lead to seizures, coma, and death.

In 1805, when the Lewis and Clark expedition obtained food from the Nez Perce tribe while trekking through the Rockies, it is thought that they were perhaps given death camas instead of blue camas, a benign plant they had eaten before. Many of the explorers were beset with violent illness; Lewis himself was seriously ill for two weeks. Since the flowers would not have been in bloom at the time, it could have been an honest mistake.

FAMILY:
Melanthiaceae

HABITAT:
Meadows

NATIVE TO:
North America, primarily in the West

COMMON NAMES:
Black snakeroot, star lily

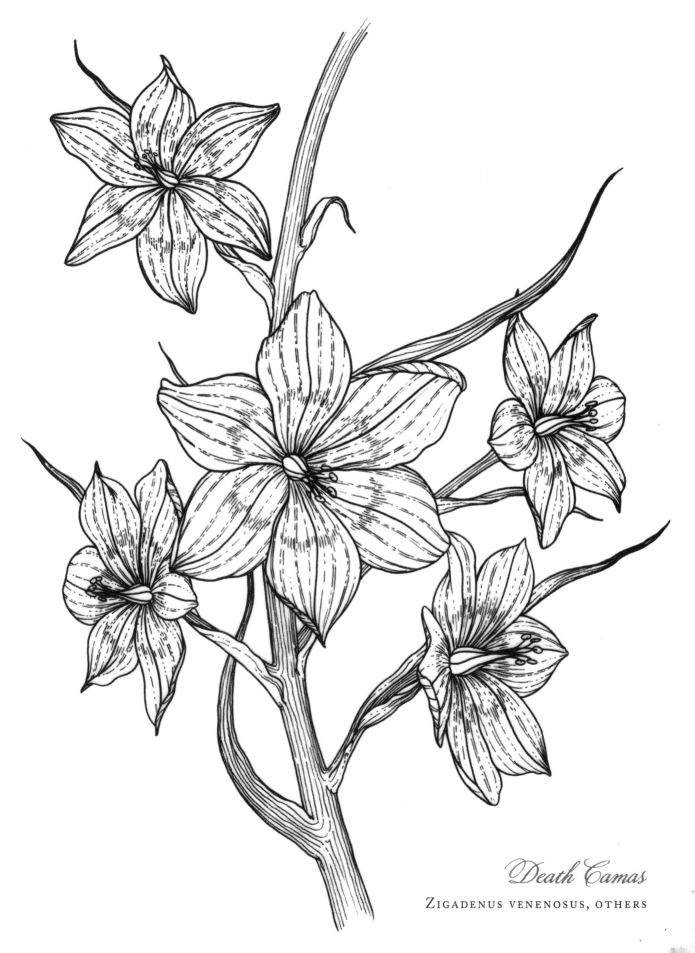

Death Camas

ZIGADENUS VENENOSUS, OTHERS

Ergot

CLAVICEPS PURPUREA

During the winter of 1691 in Salem, Massachusetts, eight young girls were suspected of demonic possession and witchcraft after they went into convulsions, babbled incoherently, and complained of creepy skin sensations. Doctors could find nothing wrong with them. Almost three hundred years later it was suggested that ergot, the toxic fungus that infects rye and contaminates bread, could explain the girls' bizarre behavior. The alkaloids in ergot constrict blood vessels, causing seizures, nausea, uterine contractions, and eventually gangrene and death.

In 1938, the Swiss pharmaceutical researcher Albert Hofmann extracted lysergic acid from ergot to make LSD.

FAMILY:
Clavicipitaceae

HABITAT:
Thrives on cereal crops such
as rye, wheat, and barley

NATIVE TO:
Europe

COMMON NAMES:
Ergot of rye, St. Anthony's fire

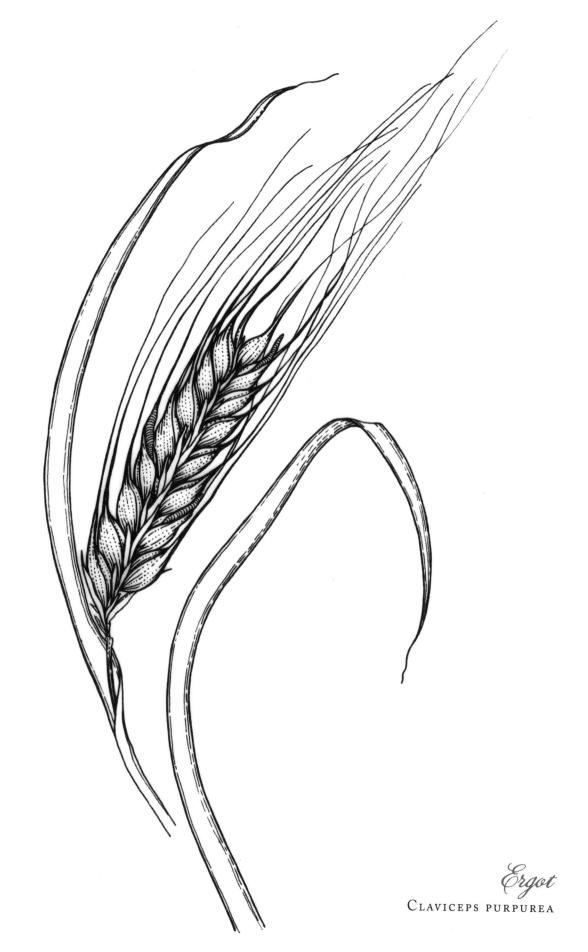

Ergot

CLAVICEPS PURPUREA

Habanero Chili

CAPSICUM CHINENSE

The heat levels in a habanero pepper approach 1 million SHU (Scoville heat units)—as a comparison, the pepper spray used by police officers clocks in at 2 million to 5 million SHU. Strangely, the active ingredient in hot peppers, capsaicin, does not actually burn. It stimulates nerve endings to send a signal to the brain that mimics a burning sensation. Capsaicin does not dissolve in water, so grabbing for the water jug to put out the fire in your mouth is useless. However, it will bind to a fat like butter, milk, or cheese. A good stiff drink is also in order, as the alcohol works as a solvent.

FAMILY:
Solanaceae

HABITAT:
Tropical climates; needs heat
and regular water

NATIVE TO:
Central and South America

COMMON NAME:
Habanero

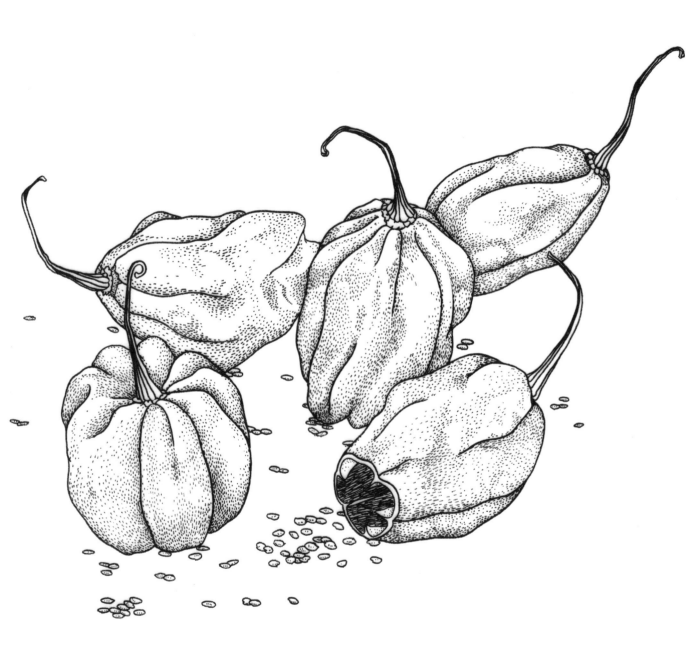

Habanero Chili

CAPSICUM CHINENSE

Henbane

HYOSCYAMUS NIGER

According to legend, henbane was a key ingredient in witches' flying potions. Although it contains alkaloids similar to those found in is close relatives, datura and belladonna, henbane is particularly known for its rank odor. The plant produces yellow flowers with what have been described as "lurid purple veins."

Henbane was used as anesthesia from Roman times until the introduction of ether and chloroform in the nineteenth century. A "soporific sponge" would be soaked in the juices of henbane, opium poppy, and mandrake, then offered to some unlucky surgical candidate to inhale. If all went well, the patient drifted into a twilight sleep—but if given too much, the patient might never wake again.

FAMILY:
Solanaceae

HABITAT:
Widespread across temperate climates

NATIVE TO:
Mediterranean Europe, North Africa

COMMON NAMES:
Hog's bean, fetid nightshade, stinking Roger; *henbane* means literally "killer of hens."

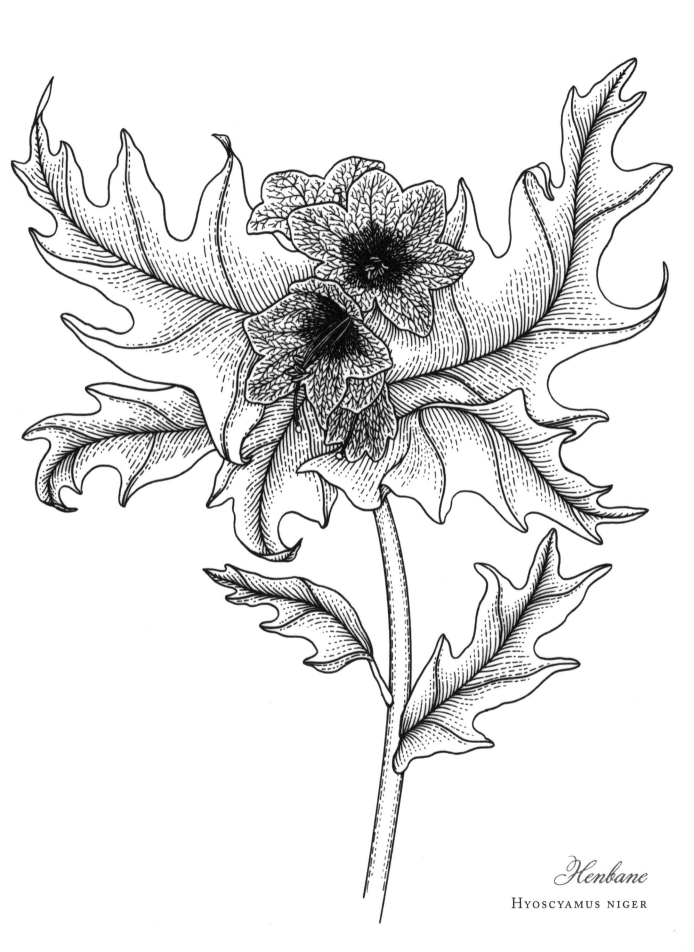

Henbane

HYOSCYAMUS NIGER

Iboga

TABERNANTHE IBOGA

Found in the tropical undergrowth of forests in the central part of Africa's west coast, iboga produces clusters of small flowers, followed by elongated orange fruit. The plant contains ibogaine, which can bring on hallucinations. Members of the Bwiti religion in West Africa use iboga in their ceremonies, believing that the hallucinations brought on by the plant allow members a way to connect with their ancestors, undergo initiation rites, and heal medical or emotional problems.

Ibogaine is also used to make a controversial medicine that some believe can cure heroin addiction, with the thought that the treatment can "reset" brain chemistry to curb drug cravings.

FAMILY:
Apocynaceae

HABITAT:
Tropical forests

NATIVE TO:
West Africa

COMMON NAMES:
Black bugbane, leaf of God

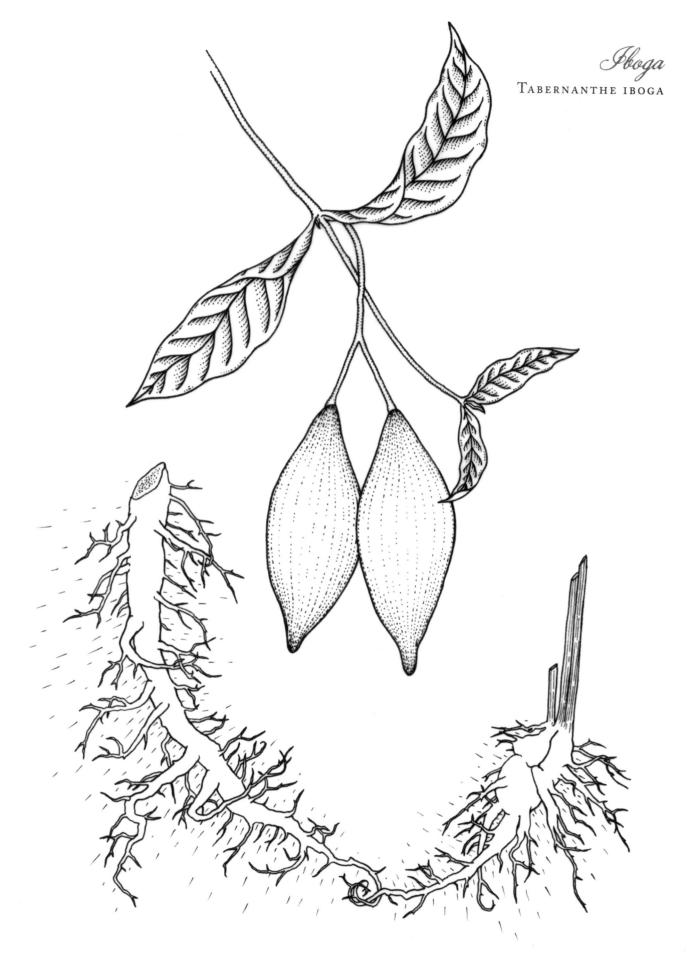

Iboga

Tabernanthe iboga

Jimson Weed

DATURA STRAMONIUM

Jimson weed fruit is about the size of a small egg, pale green, and covered in thorns. In the fall, the fruits release a generous handful of highly toxic seeds, which cause hallucinations and seizures if ingested.

In 1607, when the first settlers arrived on Jamestown Island in Virginia, they ate the plant, and many suffered gruesome deaths, probably marked by delusions, convulsions, and respiratory failure. Some seventy years later, when British soldiers sailed over to quell an uprising at the colony, the settlers slipped datura leaves into the soldiers' food. This didn't kill the soldiers, but they did go temporarily insane, giving the colonists the upper hand.

FAMILY:
Solanaceae

HABITAT:
Temperate and tropical climates

NATIVE TO:
Central America

COMMON NAMES:
Devil's trumpet, thorn apple, Jamestown weed, moonflower

Jimson Weed
DATURA STRAMONIUM

Khat

Catha edulis

The dark, glossy leaves that emerge from the red stalks of the khat plant are only potent for about forty-eight hours after harvest. After that, all that is left is a very mild chemical similar to the diet pill ephedrine.

In Yemen and Somalia up to three-quarters of adult men use the drug, stuffing khat leaves between their cheek and gum to enjoy the plant's high. When a khat plane lands in Somalia, its cargo is unloaded and distributed in a matter of hours. Under its influence, men lounge about in a blissed-out state, tending to neither their families nor their jobs. As one man put it, "I feel like my problems disappear." Alas, long-term use leads to aggression, delusions, paranoia, and psychosis.

FAMILY:
Celastraceae

HABITAT:
Tropical elevations above three thousand feet

NATIVE TO:
Africa

COMMON NAMES:
Qat, kat, chat, Abyssinian tea, miraa, jaad

Khat

Catha edulis

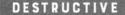

Killer Algae

CAULERPA TAXIFOLIA

A lush, green carpet of *C. taxiflolia* spans over thirty-two thousand acres of oceans around the world. This is truly remarkable considering the fact that the entire plant, including its feathery fronds, sturdy stems, and tough rhizoids that anchor it to the ocean floor, are all just one giant cell. It is one of the world's largest—and most dangerous—single-celled organisms.

Killer algae don't kill human beings. The plant gets its nickname from a toxin called caulerpenyne that poisons fish. This keeps marine life from nibbling on the plant, which is part of the reason it has spread unchecked, choking out all other aquatic life.

FAMILY:
Caulerpaceae

HABITAT:
Killer algae thrives in the Mediterranean, along California's Pacific coast, in the oceans off tropical and subtropical Australia, and in saltwater aquariums worldwide.

NATIVE TO:
Originally discovered along the French coast, this algae is native to the Caribbean, East Africa, northern India, and elsewhere.

COMMON NAMES:
Caulerpa, Mediterranean clone

Killer Algae
CAULERPA TAXIFOLIA

Kudzu

PUERARIA LOBATA

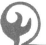udzu to the rescue!" So proclaimed a 1937 *Washington Post* article about the powers of this exotic vine to control erosion. And indeed, for almost a hundred years the vine enjoyed the enthusiastic support of American gardeners and farmers, who found it a useful forage crop for livestock. But the vine now covers seven million acres in the United States and the damage it has caused is estimated in the hundreds of millions.

Herbicide campaigns, controlled burns, and repeated slashing of new growth can keep kudzu in check. Southerners also fight back by eating the vine that is eating them, with fried kudzu leaves, kudzu blossom jelly, and kudzu stem salsa.

FAMILY:
Fabaceae

HABITAT:
Warm, humid climates

NATIVE TO:
China; introduced to Japan in the 1700s

COMMON NAMES:
Mile-a-minute vine, the vine that ate the South. To the Japanese, the word *kudzu* means "rubbish," "waste," or "useless scraps."

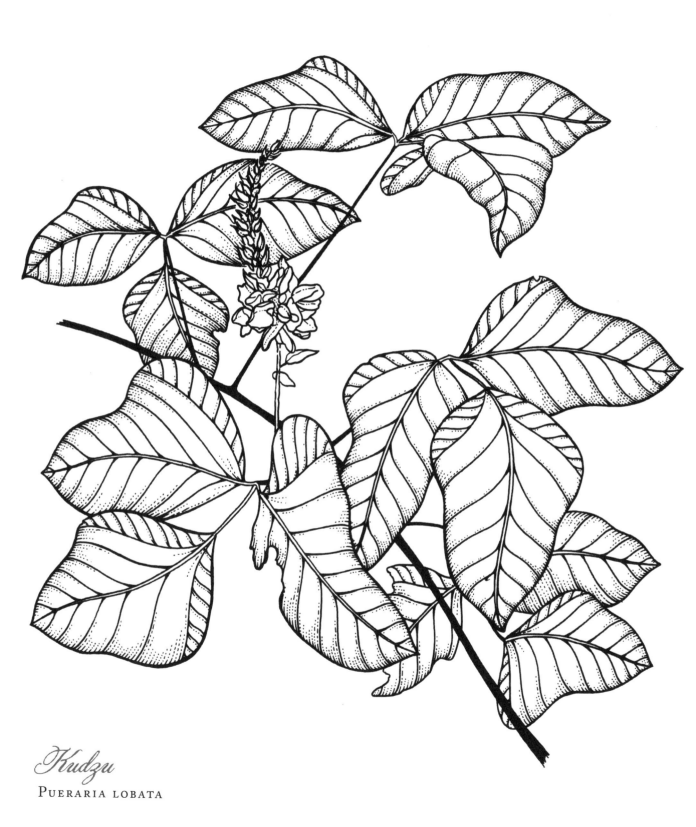

Kudzu

Pueraria lobata

Mala Mujer

CNIDOSCOLUS ANGUSTIDENS

Mala mujer, or "bad woman," is a desert-dwelling perennial shrub that has the toxic sap of a euphorbia and the tiny hypodermic needlelike hairs of a nettle. One researcher found the pain to be so excruciating that he called the trichomes "nuclear glass daggers."

According to a 1971 newspaper, mala mujer was a treatment for infidelity in Mexico; husbands would brew it into a tea to "control" their spouses' sexual urges. The wives had a much more potent treatment for men who strayed: a hallucinogenic or possibly fatal tea made from the seeds of a datura.

FAMILY:
Euphorbiaceae

HABITAT:
Dry desert environments

NATIVE TO:
Arizona and Mexico

COMMON NAMES:
Bad woman, caribe,
spurge, nettle

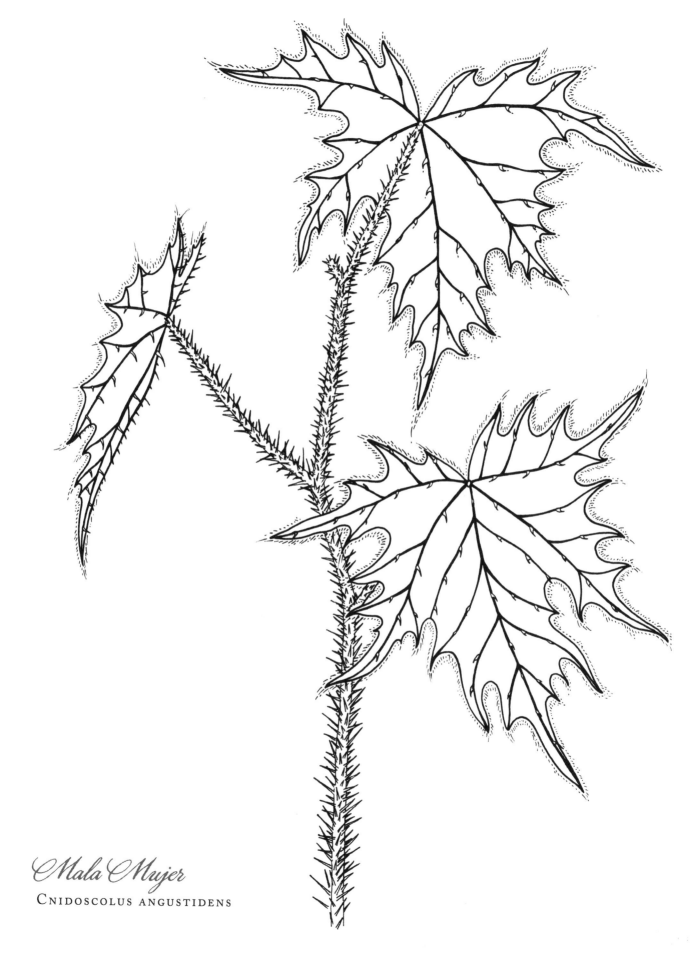

Mala Mujer

CNIDOSCOLUS ANGUSTIDENS

Manchineel Tree

HIPPOMANE MANCINELLA

Tourists vacationing in the Caribbean are routinely warned about the hazards of the manchineel tree. It produces a highly irritating sap that can squirt out of the tree when a twig is snapped off. It also produces a toxic fruit that causes blistering in the mouth and makes the throat swell closed. Even lounging under the trees might be dangerous: rain dripping off them could cause rashes and itching.

Captain James Cook and his crew had a nasty encounter with the toxic tree. After chopping manchineel wood and rubbing their eyes thereafter, some of the crew were reportedly blinded for two weeks.

FAMILY:
Euphorbiaceae

HABITAT:
Beaches on tropical islands,
Florida Everglades

NATIVE TO:
Caribbean islands

COMMON NAMES:
Beach apple, manzanillo

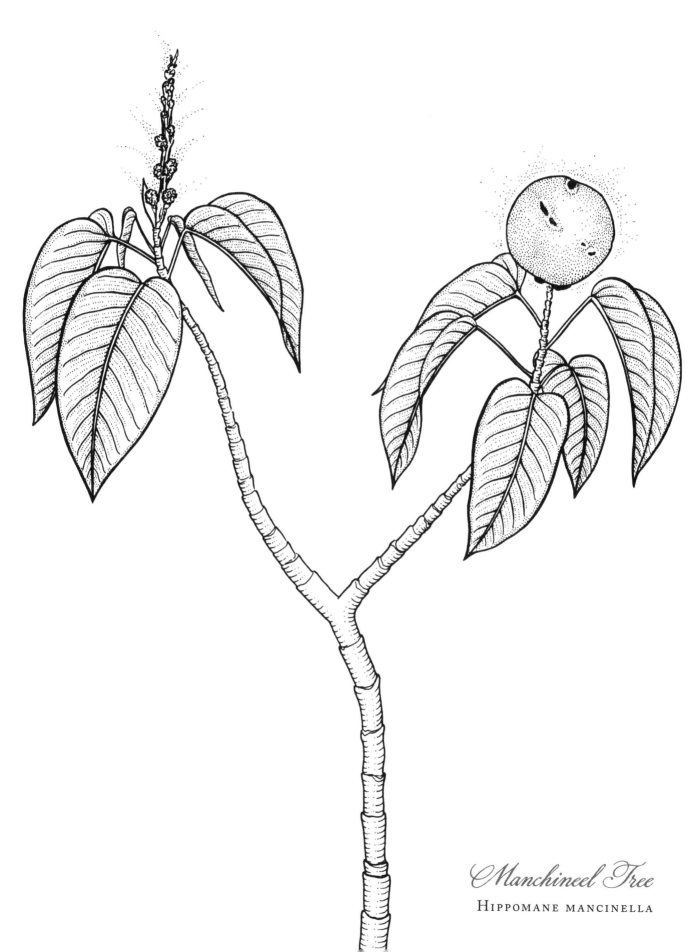

Manchineel Tree

HIPPOMANE MANCINELLA

Mandrake

MANDRAGORA OFFICINARUM

An unimposing little plant with a rosette of leaves, pale green flowers, and mildly poisonous fruits, a mandrake's true power lies underground. Members of ancient civilizations thought that the bifurcated, hairy root (which can grow three to four feet long) looked like a devilish little person. The Romans believed mandrake could cure demonic possession, and the Greeks used it in love potions.

Around 200 BC, Hannibal used the powerful sedative as chemical warfare, retreating from the city of Carthage and leaving behind a feast that included a mandrake wine. The African warriors drank and slept, only to be ambushed and killed when Hannibal's troops returned.

FAMILY:
Solanaceae

HABITAT:
Fields; open, sunny areas

NATIVE TO:
Europe

COMMON NAMES:
Satan's apple,
mandragora

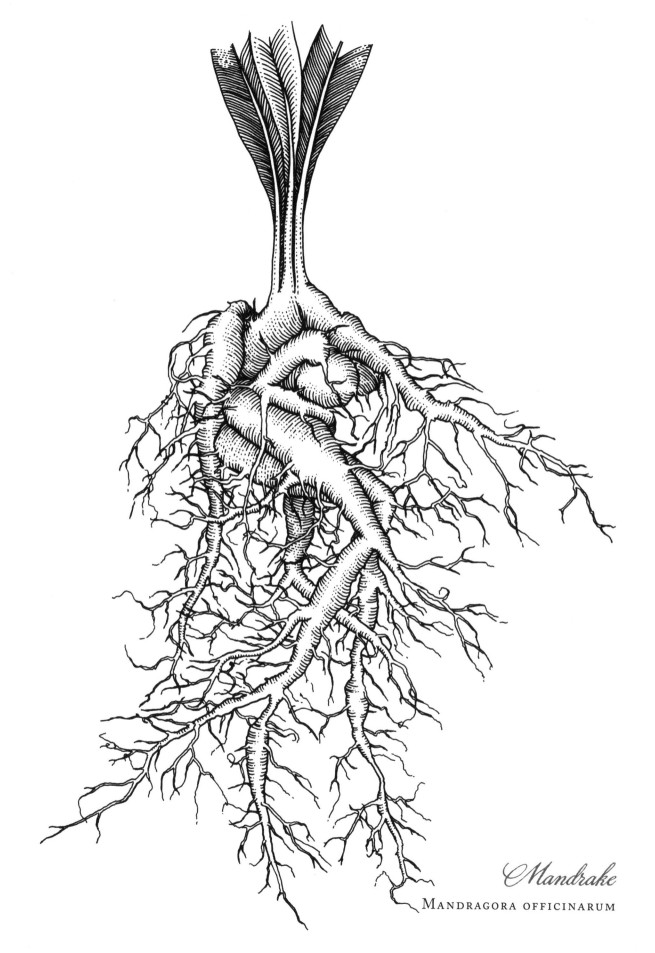

Mandrake

MANDRAGORA OFFICINARUM

Marijuana

CANNABIS SATIVA

Cannabis has been used by humans for at least five thousand years across the world—fibers have been found in caves throughout Asia; it was mentioned in Roman physician Dioscorides' medical guide *De material medica;* and even early drafts of the Declaration of Independence were written on hemp paper.

All parts of the plant contain THC, the psychoactive compound that brings on a feeling of mild euphoria, relaxation, and the sense that time is passing slowly. It may have been outlawed in the United States in 1951 as part of the Boggs Act (with laws changing to this day), but roughly a third of Americans have used marijuana in their lifetime.

FAMILY:
Cannabaceae

HABITAT:
Sunny, warm, open areas like meadows and fields

NATIVE TO:
Asia

COMMON NAMES:
Pot, ganja, Mary Jane, bud, weed, grass

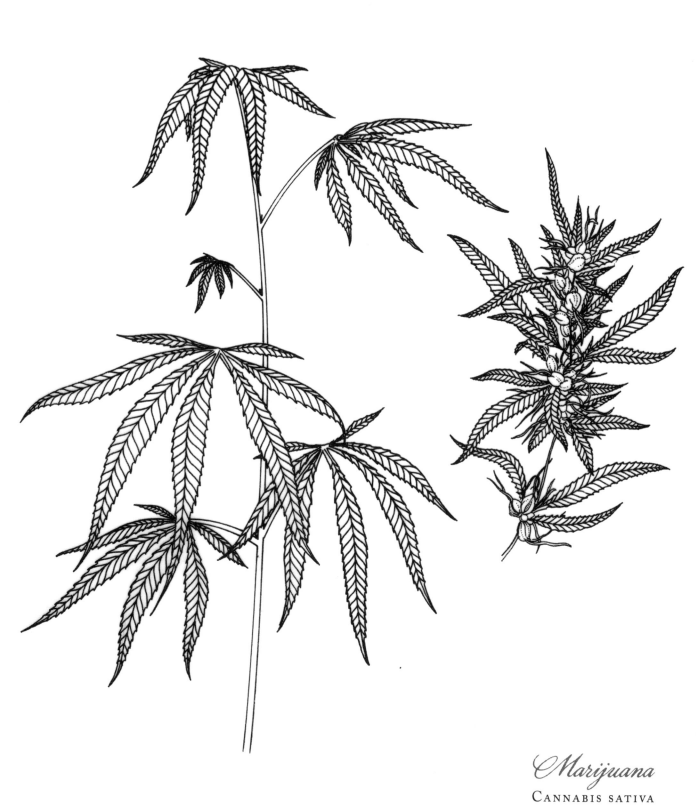

Marijuana

CANNABIS SATIVA

Oleander

NERIUM OLEANDER

This highly toxic shrub is popular in warm climates around the world for its red, pink, yellow, or white blossoms. Oleander contains oleandrin, a cardiac glyceride that brings on nausea and vomiting, severe weakness, irregular pulse, and a decreased heart rate that leads quickly to death.

Because it is so widespread, oleander has been implicated in a surprising number of murders and accidental deaths over the years. A woman in Southern California tried to kill her husband by putting oleander leaves in his food; small children have died from chewing the leaves; and oleander-related suicide attempts turn up regularly in medical literature.

FAMILY:
Apocynaceae

HABITAT:
Tropical, subtropical, and temperate climates, usually in dry, sunny locations and dry streambeds

NATIVE TO:
Mediterranean areas

COMMON NAMES:
Rose laurel, be-still tree

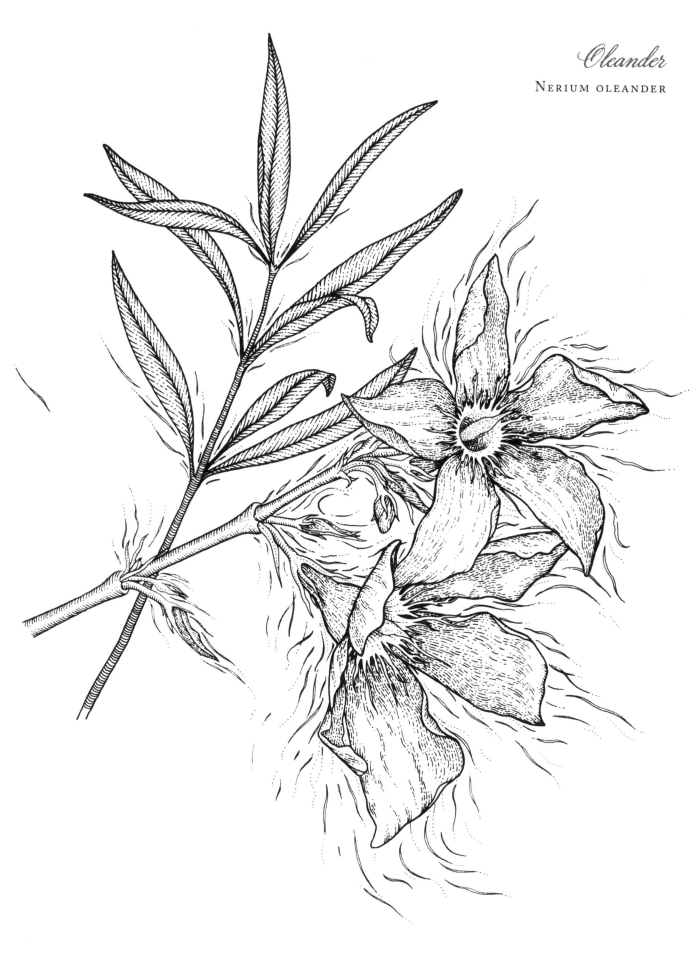

Oleander

NERIUM OLEANDER

Opium Poppy

Papaver somniferum

Experienced gardeners have no trouble distinguishing the opium poppy from its nonnarcotic cousins. The plant's smooth, bluish-green leaves; enormous pink, purple, white, or red petals; and fat blue-green seedpods give it away. The seedpods' sap produces opium, which contains morphine, codeine, and other opiates.

In 460 BC, Hippocrates championed opium as a painkiller, and its use as a recreational drug dates back to the Middle Ages. It was used in the medication called laudanum in the seventeenth century, but the drug company Bayer introduced the most popular extract in 1898 in a new product, Heroin, sold as a cough syrup for children and adults.

FAMILY:
Papaveraceae

HABITAT:
Temperate climates, sun,
rich garden soil

NATIVE TO:
Europe and western Asia

COMMON NAMES:
Breadseed poppy, peony
poppy, Turkish poppy, "hens
and chicks" poppy

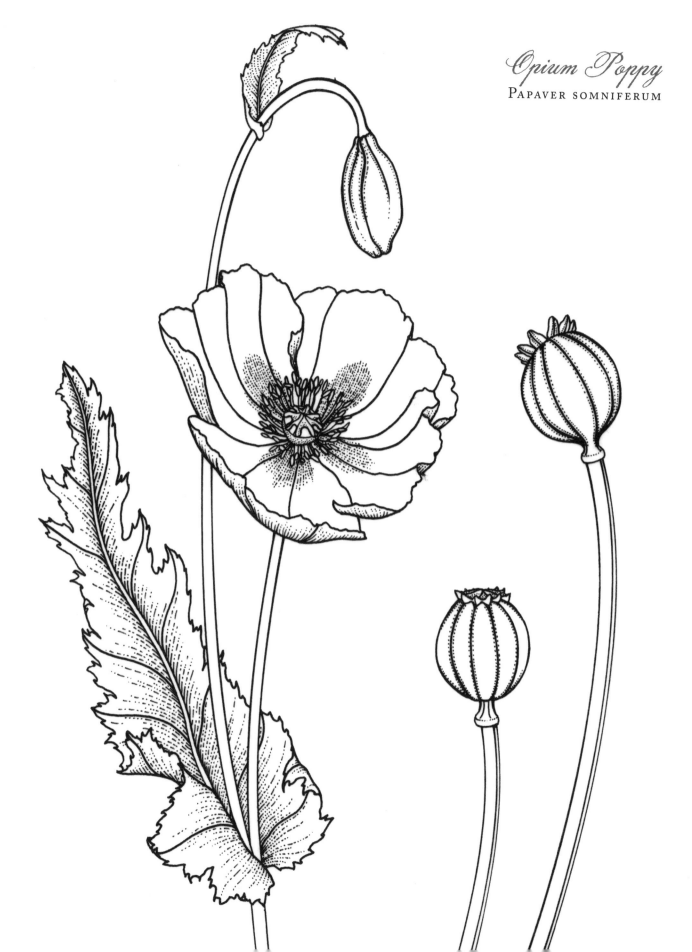

Peacock Flower

Caesalpinia pulcherrima
(*syn.* Poinciana pulcherrima)

This beautiful tropical shrub, with its fine, lacy leaves and brilliant orange, red, or yellow flowers, plays a tragic role in the history of the slave trade. In the eighteenth century, slave women in the West Indies who did not wish to contribute to the wealth of a slave owner by bearing children would attempt to end their pregnancies using the plant's poisonous seedpods. It was believed the plant would help bring on menstruation, or "bring down the flowers" as European doctors sometimes called it.

In later years, the peacock flower became a popular ornamental shrub among plant collectors in Europe, and it flourishes throughout the southern United States.

FAMILY:
Fabaceae

HABITAT:
Tropical and subtropical mountain slopes, lowland rain forest

NATIVE TO:
West Indies

COMMON NAMES:
Red bird of paradise, Barbados pride, ayoowiri, flos pavonis, tsjétti mandáru

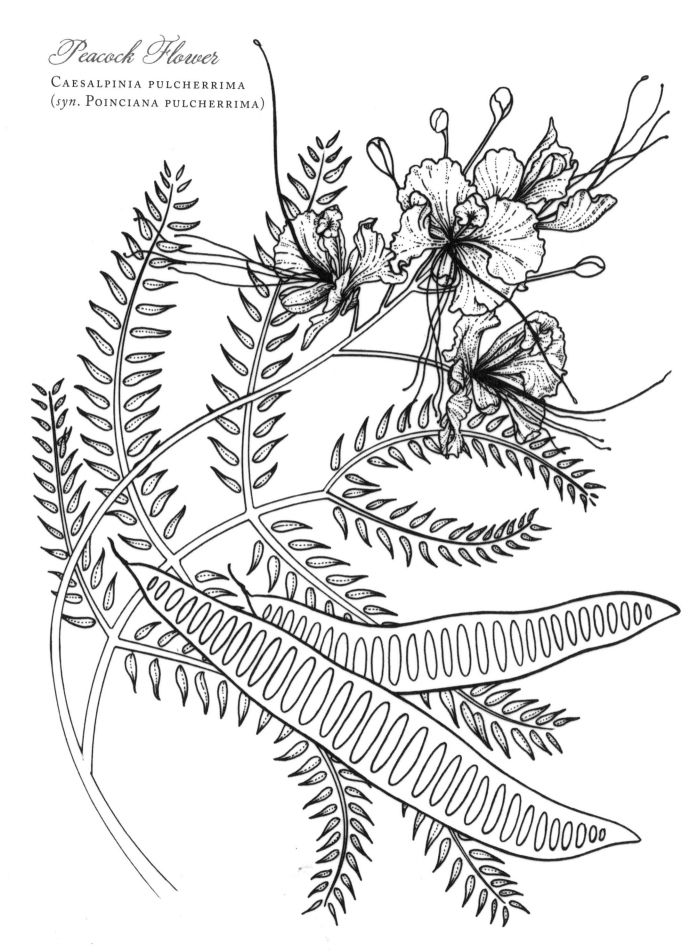

Peacock Flower

CAESALPINIA PULCHERRIMA
(*syn.* POINCIANA PULCHERRIMA)

Peyote Cactus

LOPHOPHORA WILLIAMSII

This diminutive, slow-growing cactus forms the shape of a button one to two inches across, with no spines. Left to its own devices, a small white flower blooms on top of the cactus and then goes to seed.

The bitter, dried buttons are either eaten or made into a tea. After the initial effects of nausea and vomiting, the hallucinations that follow have been described as an intense experience of bright colors, increased awareness of sounds, and clarity of thought.

When Spanish missionaries arrived in the New World, they observed the ritual use of the peyote cactus (mescaline) by Native Americans and called it witchcraft. Today, peyote is still legally used in Native American religious ceremonies.

FAMILY:
Cactaceae

HABITAT:
Desert, but prefers some humidity for seed germination

NATIVE TO:
Southwestern United States and Mexico

COMMON NAMES:
Peyote, buttons, mescaline, challote, devil's root, white mule

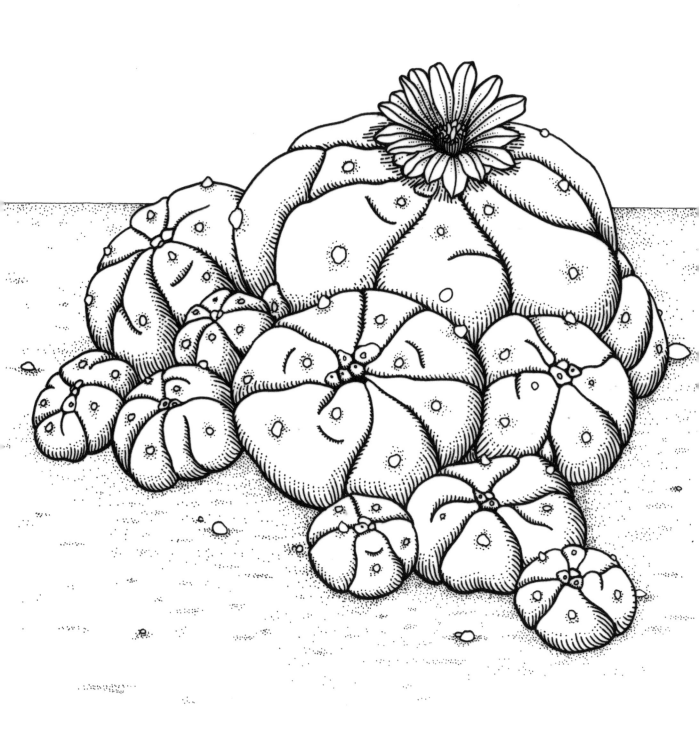

Peyote Cactus

Lophophora williamsii

Poison Hemlock

CONIUM MACULATUM

Poison hemlock, a plant in the carrot family, is so toxic that it is known in Scotland as "deid men's oatmeal." The young plants emerge in spring, and their finely cut leaves and pointed taproots look deceptively like those of parsley or carrots. They can reach over eight feet tall in one season, producing delicate flowers that resemble Queen Anne's lace. The stems are hollow and speckled with purple blotches that are sometimes called the blood of Socrates. When the Greek philosopher was sentenced to death, he was given a drink made from the plant's poison.

FAMILY:
Apiaceae

HABITAT:
Fields and pastures throughout the Northern Hemisphere; prefers wet soils and coastal areas

NATIVE TO:
Europe

COMMON NAMES:
Spotted parsley, spotted cowbane, bad-man's oatmeal, poison snakeweed, beaver poison

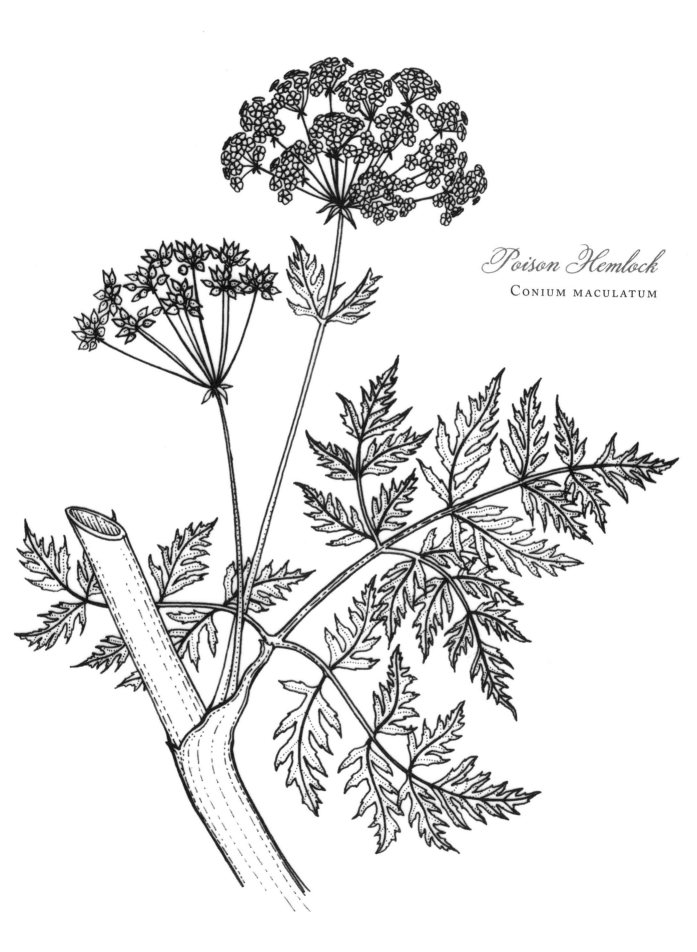

Poison Hemlock

CONIUM MACULATUM

Purple Loosestrife

Lythrum salicaria

Purple loosestrife reaches ten feet tall and five feet wide, and as many as fifty stems, with spikes of bright purple flowers, can sprout from a single taproot. It is surely one of the worst invaders the American landscape has seen, clogging wetlands and waterways and choking out other plant life.

A few species of root weevils and leaf-eating beetles have been released as a form of biological control, and it's working. So far, it does not appear that the bugs eat native plants, but introducing one exotic creature to control another always has its risks.

FAMILY:
Lythraceae

HABITAT:
Temperate meadows and wetlands

NATIVE TO:
Europe

COMMON NAMES:
Purple lythrum, rainbow weed, spiked loosestrife

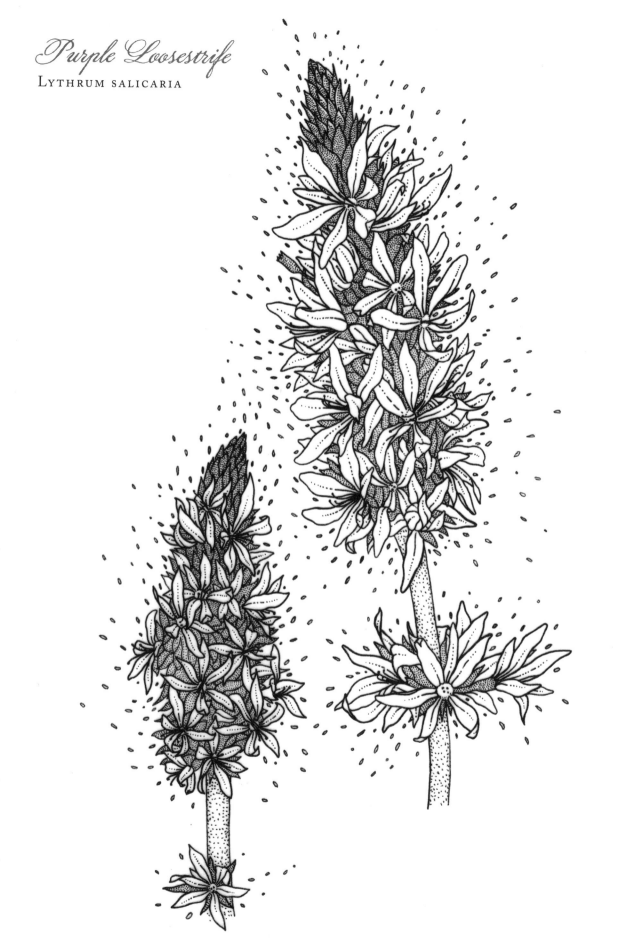

Purple Loosestrife

Lythrum salicaria

Ratbane

Dichapetalum cymosum
or D. toxicarium

These flowering trees in West Africa produce the deadly poison sodium fluoroacetate. In the 1940s, scientists discovered they could extract the poison and create a potent chemical for controlling rats and predatory animals like coyotes. The poison lingers in the body; if the animal is eaten by another animal, it can poison the rest of the food chain. For this reason, ratbane is sometimes referred to as "the poison that keeps on killing."

FAMILY:
Dichapetalaceae

HABITAT:
Tropical and subtropical areas

NATIVE TO:
Africa

COMMON NAMES:
Poison leaf, rat poison plant

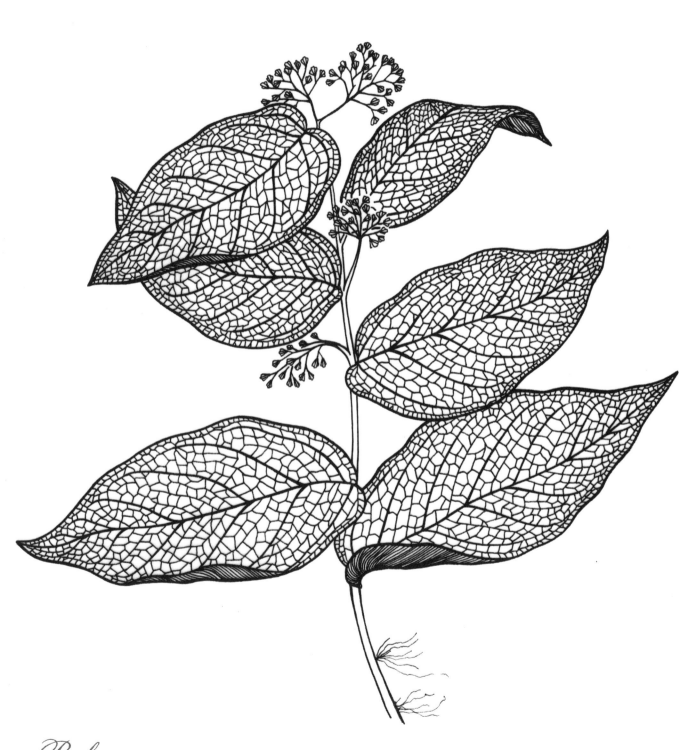

Ratbane

DICHAPETALUM CYMOSUM
or D. TOXICARIUM

Rosary Pea

ABRUS PRECATORIUS

Each glossy seed of the rosary pea is bright red with one black dot at the hilum, which is the scar left behind where the pea attached to the pod. They are the size and color of a ladybug, making them popular beads for jewelry making.

They are also so toxic that a single seed, chewed well, would kill a person. In fact, punching holes in the hard shells to run a piece of string through the seeds puts a jewelry maker at risk: a finger prick with a needle in the presence of even small quantities of rosary pea dust could be fatal.

FAMILY:
Fabaceae

HABITAT:
Dry soil, low elevations,
tropical climates

NATIVE TO:
Tropical Africa and Asia;
naturalized in tropical
and subtropical regions
throughout the world

COMMON NAMES:
Jequirity bean, precatory
bean, deadly crab's eye, ruti,
Indian licorice, weather plant

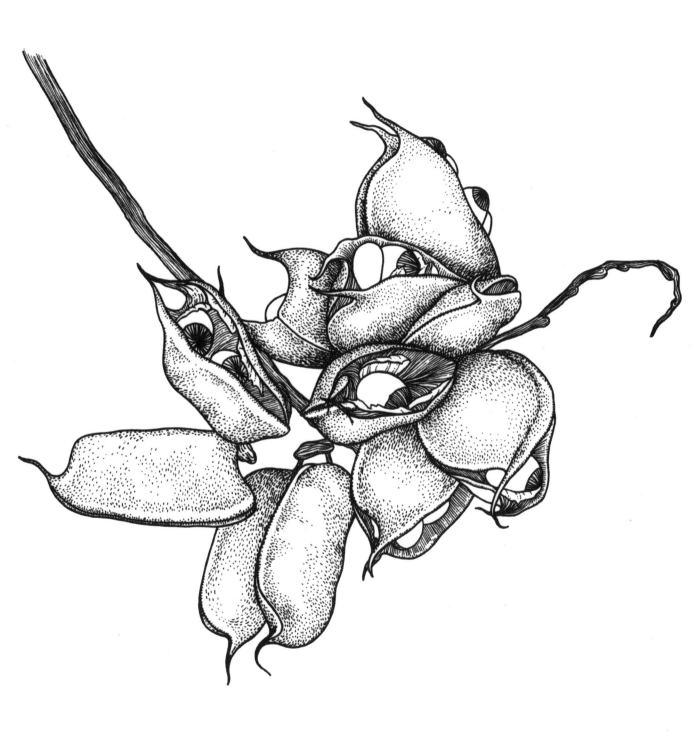

Rosary Pea
ABRUS PRECATORIUS

Sago Palm

CYCAS SPP.

Sago palm is widely used as a feature plant in home landscapes and botanical gardens. What most people don't realize is that all parts of the plants, especially the leaves and seeds, contain carcinogens and neurotoxins.

Pets are routinely poisoned by nibbling on the plant—and it has also caused widespread harm to humans. Scientists traced a mysterious variant of ALS (also known as Lou Gehrig's disease) that broke out in Guam back to the poisonous compounds of the sago palm, which locals had eaten during food shortages during World War II.

FAMILY:
Cycadaceae

HABITAT:
Tropics, some desert environments

NATIVE TO:
Southeast Asia, Pacific Islands, and Australia

COMMON NAMES:
False sago, fern palm, cycad

Sago Palm

CYCAS SPP.

Stinging Tree

DENDROCNIDE MOROIDES

The stinging tree reaches about seven feet in height and produces tempting clusters of red fruit that resemble raspberries. Every inch is covered with fine silicon hairs that resemble peach fuzz and contain a virulent neurotoxin.

Anyone walking through the Australian rain forest would be well advised to keep an eye out for this plant. It can easily penetrate most kinds of protective clothing. A common treatment is the application of a hair removal wax strip, which will pull out the plant's fine hairs along with your own. Experts recommend a shot of whisky before attempting this treatment.

FAMILY:
Urticaceae

HABITAT:
Rain forests, particularly in disturbed areas, in canyons, or on slopes

NATIVE TO:
Australia

COMMON NAMES:
Gympie gympie, moonlighter, stinger, mulberry-leaved stinger

Stinging Tree

Dendrocnide moroides

Strychnine Tree

STRYCHNOS NUX-VOMICA

Strychnine, which comes from the seed of a fifty-foot-tall tree, takes control of the nervous system, flicking on a switch that leads to a flood of painful, unstoppable signals. Every muscle in the body goes into violent spasm, and the victim dies of respiratory failure or sheer exhaustion.

Strychnine was the poison of choice of the nineteenth-century serial killer Dr. Thomas Neill Cream, who would slip the powdered seed into his victims' drinks, eventually leading to his arrest. By the age of forty-two, he was tried, convicted, and hanged.

FAMILY:
Loganiaceae

HABITAT:
Tropical and subtropical climates; prefers open, sunny areas

NATIVE TO:
Southeast Asia

COMMON NAMES:
Strychnine, nux-vomica, quaker button, vomit nut

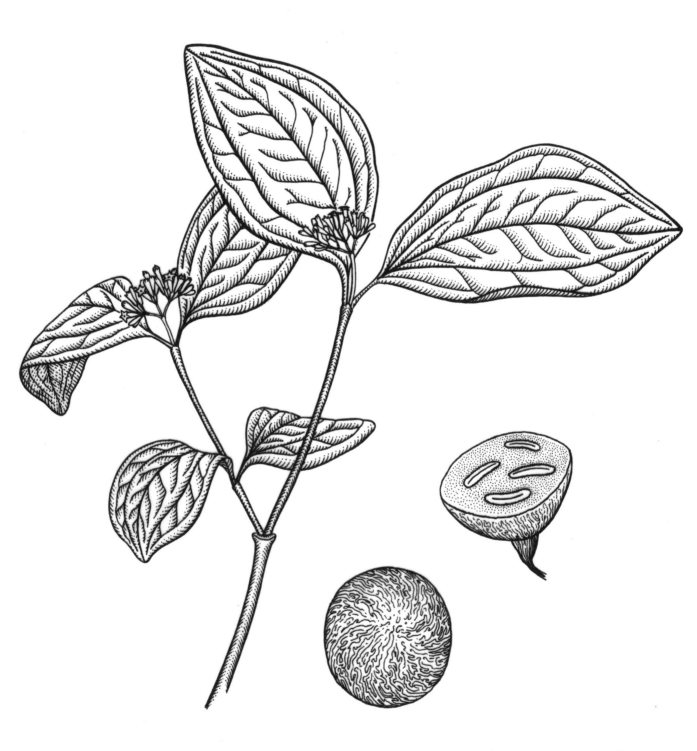

Strychnine Tree
S T R Y C H N O S N U X - V O M I C A

Suicide Tree

CERBERA ODOLLAM

In the humid, brackish lagoons of the Kerala backwaters on the southwestern coast of India grows the suicide tree. Its narrow, dark green leaves resemble those of its cousin, the common oleander. Sprays of starry white flowers release a perfume as sweet as jasmine. The fleshy green fruit conceals a nasty surprise: the seed's white nut meat contains enough cardiac glycosides to stop the heart within three to six hours.

The advantages of such a powerful natural resource are not lost on the locals. In 2004, a team of French and Indian scientists conducted analyses to prove that many of those who had died under mysterious circumstances in the region had actually been fed odollam by some homicidal acquaintance.

FAMILY:
Apocynaceae

HABITAT:
Mangrove swamps and riverbanks in southern India, as well as Southeast Asia

NATIVE TO:
India

COMMON NAMES:
Othalanga maram, kattu arali, famentana, kisopo, samanta, tangena, pong-pong, buta-buta, nyan

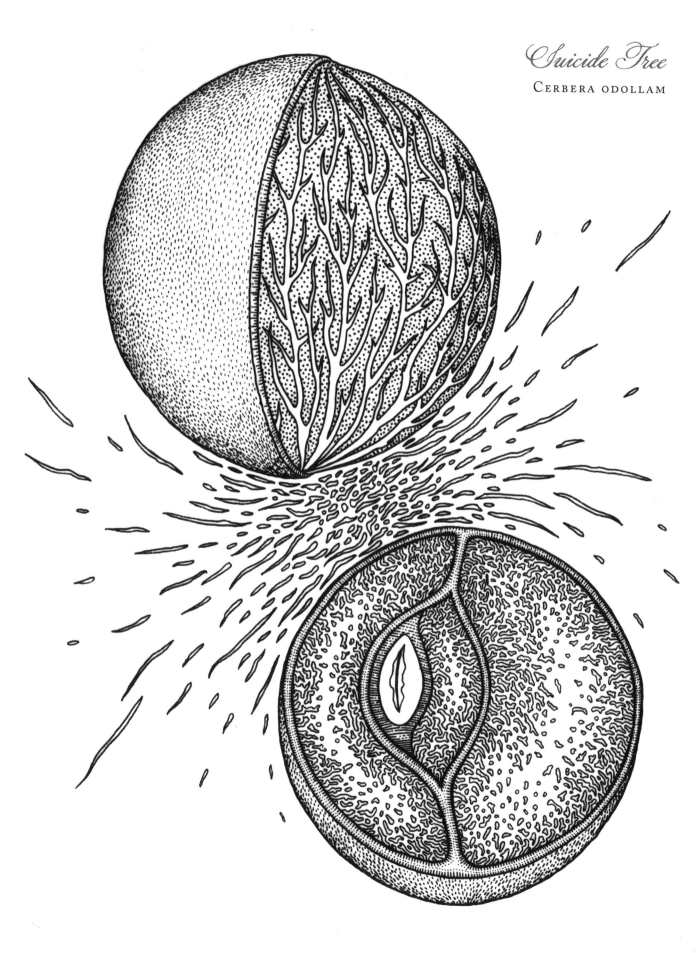

Suicide Tree

CERBERA ODOLLAM

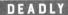

Tobacco

Nicotiana tabacum

Throughout history, people didn't just smoke tobacco; they also believed it could cure migraines, ward off the plague, and, ironically, treat coughs and cancer. But smoking wasn't embraced by everyone, even in the early days. In 1604 King James I called it "loathsome" and said that it was "harmful to the brain, dangerous to the lungs." His statement was proven correct time and again over the next four hundred years, but tobacco use only grew.

It's so addictive that humans have been persuaded to grow it in mass quantity, and some 1.3 billion people around the world hold it between their trembling fingers every day.

FAMILY:
Solanaceae

HABITAT:
Warm, tropical and subtropical, mild-winter areas

NATIVE TO:
South America

COMMON NAME:
Henbane of Peru

Tobacco

Nicotiana tabacum

Toxic Blue-Green Algae

CYANOBACTERIA

Pond scum may not technically be a plant—this particular form of algae is actually classified as a bacterium—but it poses a serious threat to humans and animals. This toxic blue-green algae can reproduce or "bloom" suddenly, releasing poisons into the water.

In 1961 residents in Santa Cruz, California, awoke to the sound of birds slamming against their homes. Locals found dead birds in the street and disoriented, sickened gulls rushing straight at their flashlights in the dark. This story drew the attention of Alfred Hitchcock, who had considered basing a film on Daphne du Maurier's story "The Birds," and it motivated him to get to work on the film. It took more than forty years for scientists to realize that the bizarre behavior of those seagulls was probably caused by a toxic algae bloom that poisoned the anchovies the birds ate.

KINGDOM:
Bacteria

HABITAT:
Saltwater and freshwater environments worldwide, including oceans, rivers, ponds, lakes, and streams

NATIVE TO:
Everywhere; even present in the fossil record from 3.5 billion years ago

COMMON NAME:
Toxic algae

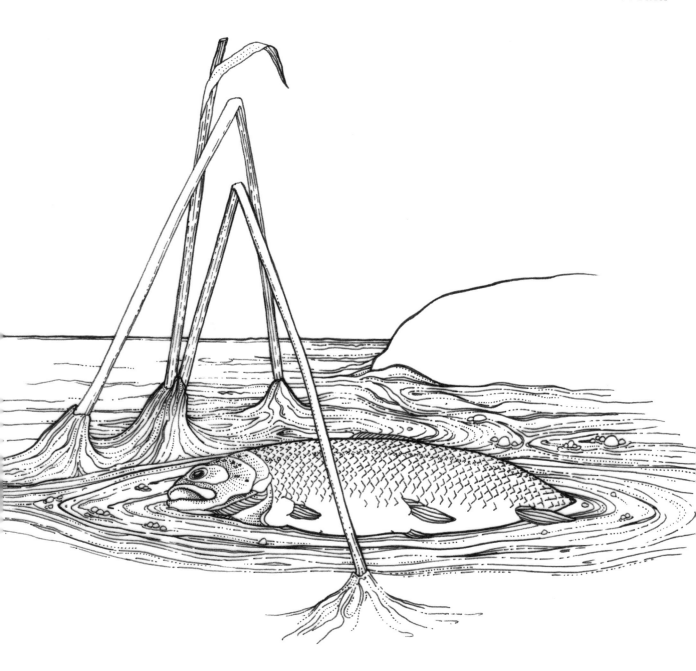

Water Hemlock

CICUTA SPP.

Water hemlock, which thrives in pastures and swamps, is widely regarded as one of the most dangerous plants in the United States. Its flat, umbrella-shaped clusters of white flowers and lacy foliage resemble that of its more edible relatives like coriander, parsnips, and carrots. In fact, most accidental poisonings from water hemlock come about because people mistakenly believe the roots are edible. It only takes a nibble or two to get a lethal dose of the plant's toxin, cicutoxin, and a single root could kill a sixteen-hundred-pound cow.

FAMILY:
Apiaceae

HABITAT:
Temperate climates, usually near rivers and wetlands

NATIVE TO:
North America

COMMON NAMES:
Cowbane, wild carrot, snakeweed, poison parsnip, false parsley, children's bane, death-of-man

Water Hemlock

Cicuta spp.

Water Hyacinth

Eichhornia crassipes

This South American native grows to about three feet tall in water and sports luscious lavender blooms with a distinctive yellow spot on just one of its six petals. Although it is beautiful, this aquatic plant forms dense sprawling mats on the water's surface that even commercial boats can't penetrate. Its crimes are abundant: choking waterways, clogging power plants, starving the locals, stealing water, stealing nutrients, and breeding nasty pests (most notably, malarial mosquitoes).

While natural predators kept the plant from taking over its native Amazon, it has gone on a crime spree in Asia, Australia, the Americas, and parts of Africa. It has earned its own Guinness World Record as the world's worst aquatic weed.

FAMILY:
Pontederiaceae

HABITAT:
Tropical and subtropical lakes
and rivers

NATIVE TO:
South America

COMMON NAMES:
Floating water hyacinth,
jacinthe d'eau, jacinto de agua

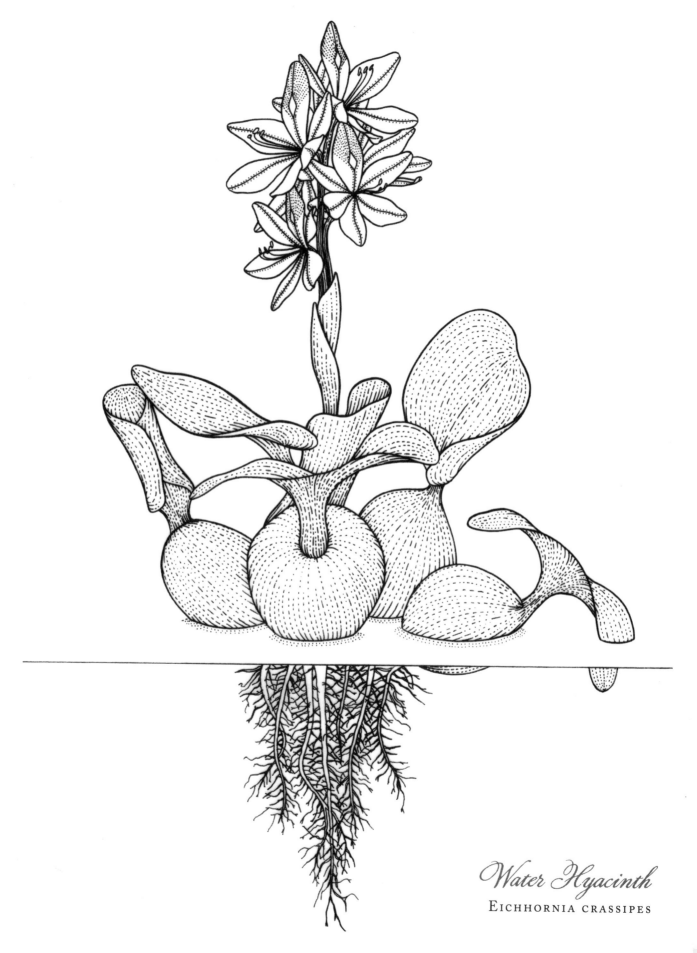

Water Hyacinth

EICHHORNIA CRASSIPES

Whistling Thorn Acacia

ACACIA DREPANOLOBIUM

This scrubby East African tree employs painful, three-inch thorns to keep browsers away from its lacy leaves. Four different species of ants have taken up residence in these trees, but they can't occupy the same tree without going to war with one another. These ferocious ants will swarm over a giraffe or other grazing animal to keep it from destroying their home. They live in the swollen bases of acacia thorns, which they enter by chewing a hole through the thorn. That small hole creates the strange whistling sound the tree makes in the wind.

FAMILY:
Fabaceae or Leguminosae

HABITAT:
Dry tropics, Kenya

NATIVE TO:
Africa

COMMON NAME:
Whistling thorn

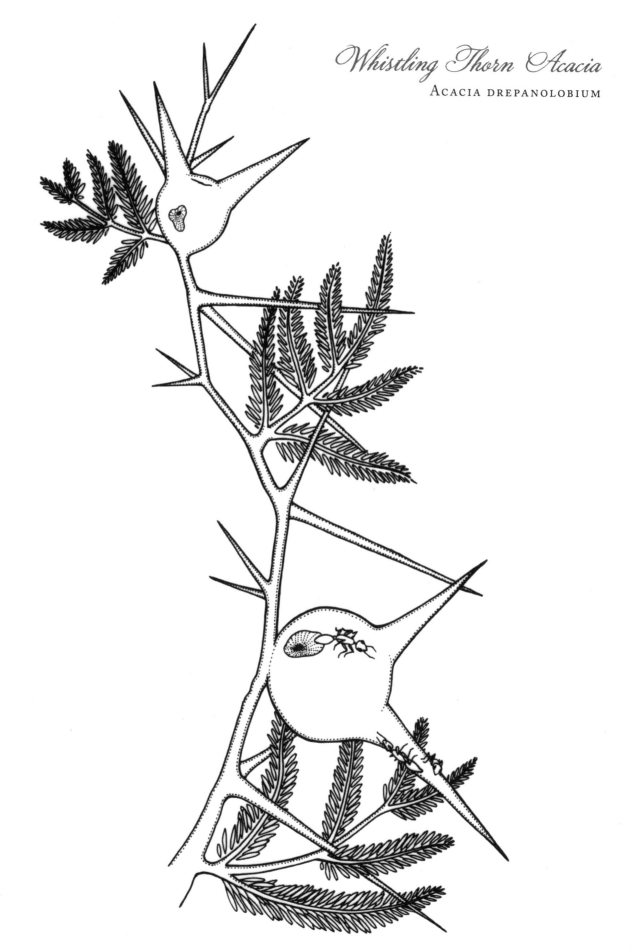

White Snakeroot

Eupatorium rugosum
(*syn.* Ageratina altissima)

Milk sickness was an all-too-common hazard of early farm life in America, and it claimed Nancy Hanks Lincoln, mother of Abraham Lincoln, as one of its victims. When cattle also started showing symptoms of the disease, farmers stood by helplessly, not realizing that the plant the cattle grazed on was to blame.

An Illinois doctor named Anna Bixby noticed the seasonality of the disease and speculated that it might have to do with the emergence of a particular plant in summer, with white clusters of flowers similar in shape to Queen Anne's lace. Unfortunately, Bixby's attempts to notify authorities fell on deaf ears, since female doctors were not taken seriously; it was not until the 1920s that the dangers of white snakeroot were recognized.

FAMILY:
Asteraceae (or Compositae)

HABITAT:
Woodlands, thickets, meadows, and pastures

NATIVE TO:
North America

COMMON NAME:
White sanicle

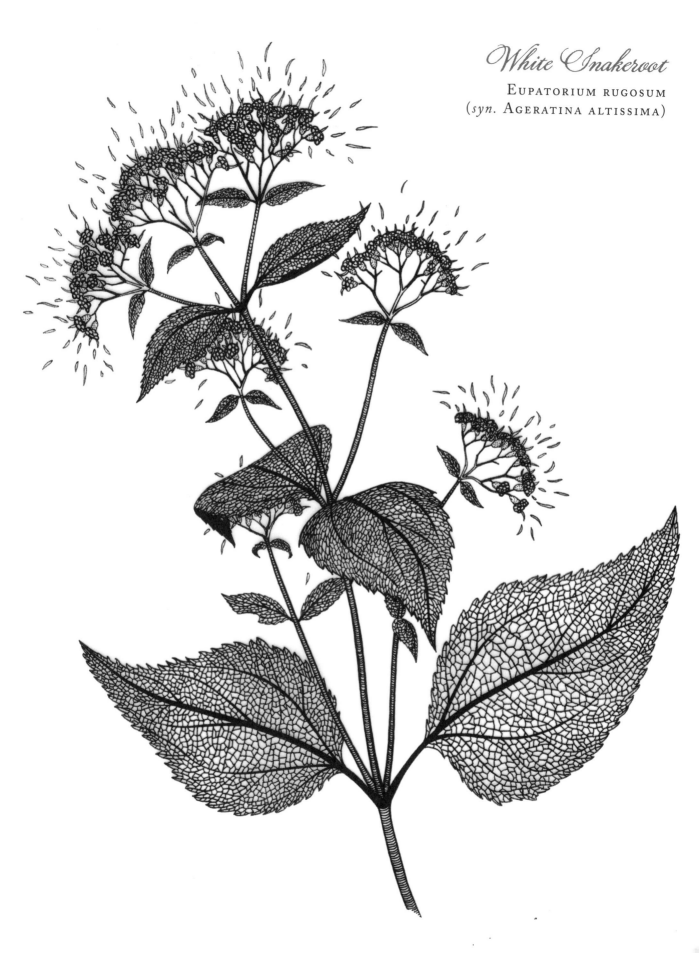

White Snakeroot

Eupatorium rugosum
(*syn.* Ageratina altissima)

Yew

Taxus baccata

The yew is a slow-growing evergreen with fine, needlelike leaves and red fruit, which make it an attractive landscape tree. It can live two or three centuries and can easily reach seventy feet in height. Every part of the yew is poisonous with the exception of the flesh of its red berrylike fruit (called an aril), and even that contains a toxic seed.

It is known as the graveyard tree in England—not for its ability to send people to an early grave but because Roman invaders began offering church services in the shade of yew trees, hoping that this would appeal to the pagan population. Today ancient yew trees are still found near churches in the English countryside.

FAMILY:
Taxaceae

HABITAT:
Temperate forests

NATIVE TO:
Europe, Northwest Africa,
Middle East, parts of Asia

COMMON NAMES:
Common yew, European or
English yew

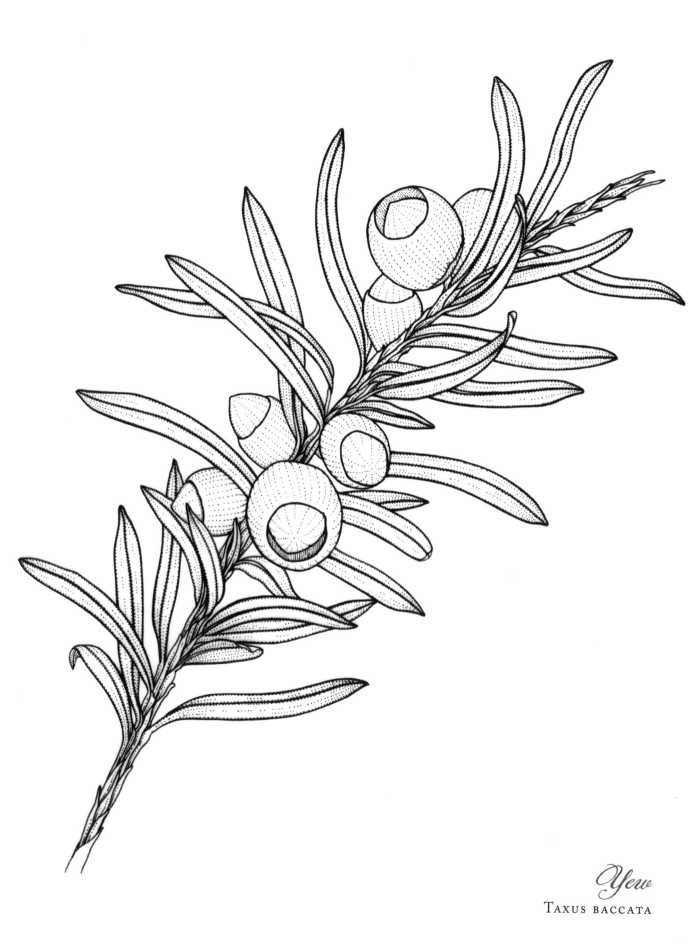

Yew

Taxus baccata

AMY STEWART is the award-winning author of six books on the perils and pleasures of the natural world. She is the cofounder of the popular blog *Garden Rant* and is a contributing editor at *Fine Gardening* magazine. She and her husband live in Eureka, California, where they own an antiquarian bookstore called Eureka Books.

BRIONY MORROW-CRIBBS completed her MFA at the University of Wisconsin–Madison, where she also taught etching. She has shown both nationally and internationally, with solo exhibitions in the Davidson Galleries in Seattle; the Artisan Gallery in Paoli, Wisconsin; and the Tory Folliard Gallery in Milwaukee. Morrow-Cribbs illustrated two *New York Times* bestsellers— *Wicked Plants* and *Wicked Bugs*—both written by Amy Stewart, and a book of short stories titled *Unnatural Creatures,* edited by Neil Gaiman and Maria Dahvana Headley.

AMY STEWART'S bestselling gardening books reveal all the perils and pleasures of the natural world.

WICKED PLANTS
The Weed That Killed Lincoln's Mother & Other Botanical Atrocities

From the poisonous aconite to the toxic yew, this compendium of more than two hundred of Mother Nature's most dastardly creations will entertain, enlighten, and alarm even the most intrepid nature lovers.

WICKED BUGS
The Louse That Conquered Napoleon's Army & Other Diabolical Insects

This captivating mixture of history, science, murder, and intrigue begins with the appalling African bat bug and ends with the zombie-like emerald cockroach wasp, as it explores the lives of more than one hundred of our worst insect enemies.

THE DRUNKEN BOTANIST
The Plants That Create the World's Great Drinks

A fascinating concoction of biology, botany, chemistry, etymology, and mixology that features more than fifty drink recipes and growing tips for gardeners.

THE EARTH MOVED
On the Remarkable Achievements of Earthworms

This subterranean adventure seeks out our planet's most important gatekeeper, the humble earthworm, which, though deaf, spineless, and blind, has profound effects on the ecosystem.

You'll find them wherever books and e-books are sold.